Duplicity in the mirror

Copyright © 2018 Cinzia Bianucci
Tutti i diritti riservati.
Codice ISBN: 9781791590307

DUPLICITY IN THE MIRROR

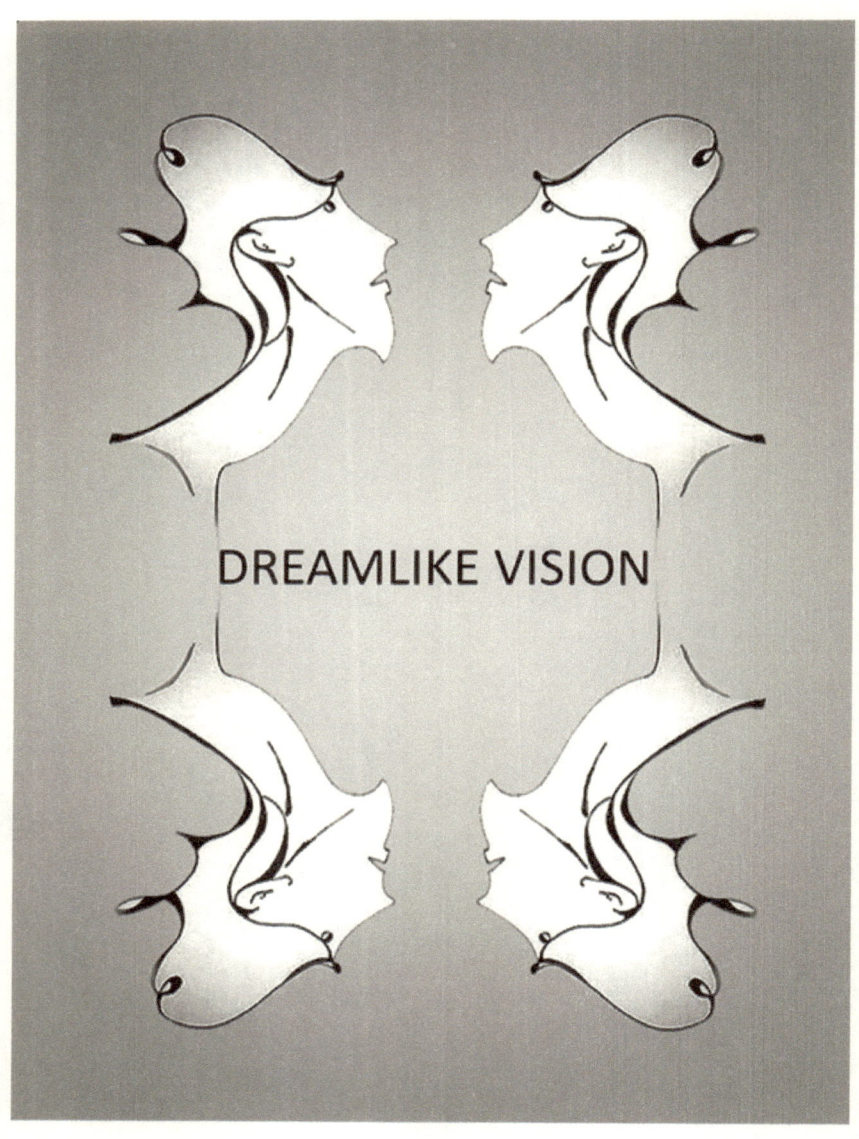

REFLECTION AND HUMAN DUPLICITY

ARTISTIC EXPERIMENTS

PROFILES AND VISIONS

I am a wandering observer and with creativity I pursue new experiences, feelings and moods.

With this sequence of 17 boards my curiosity inspected the reflection of the ego through imaginary profiles in the mirror.

These faces schematized in the double exposition are creative experiments, investigative tools with the narrative intent of depicting the doubling of human consciousness.

Dreamlike visions and suggestions that investigate and recount the reflection of identity with my personal perception of visionary surrealism.

ARTISTI EXPERIMENTS

1. A QUESTION OF PERCEPTION
2. SUSPENDED EGO
3. FRAGMENTS OF REALITY
4. VANITAS VANITATUM
5. CADUCITY
6. ABSTRACT CONCEPT
7. REFLECTION
8. SELF REPRESENTATION
9. THE PLURAL EGO
10. THE TRUTH
11. MULTIPLE IDENTITY
12. THE HEADQUARTER OF EGO
13. THE IMAGINARY EGO
14. OBJECTIVE IMAGE
15. DUAL MODE
16. THE OPPOSITES
17. CONTEMPLATION

Chapter one

A QUESTION OF PERCEPTION

I See myself, I recognize myself, I perceive myself, I lose myself in ambiguous sensations.

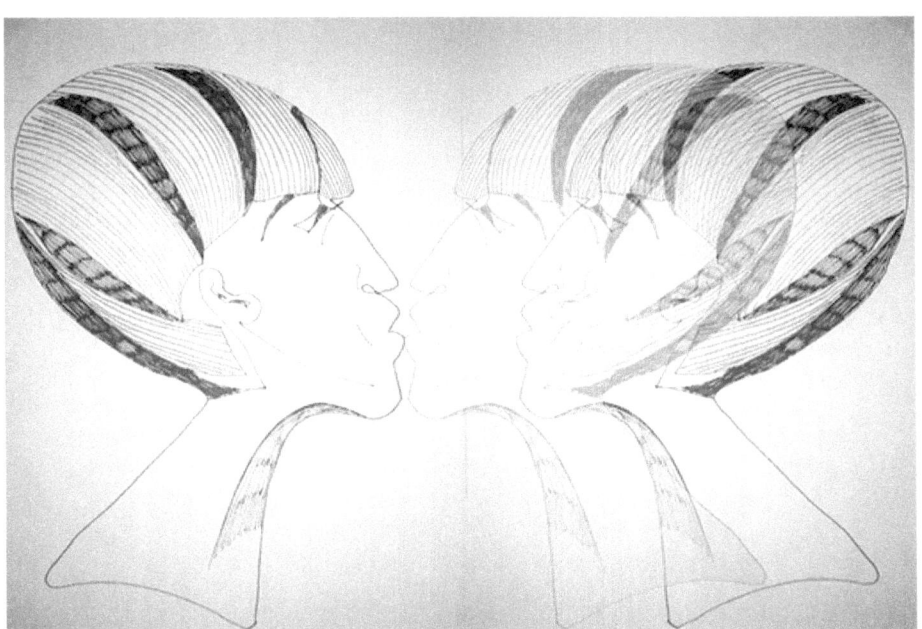

DUPLICITY IN THE MIRROR

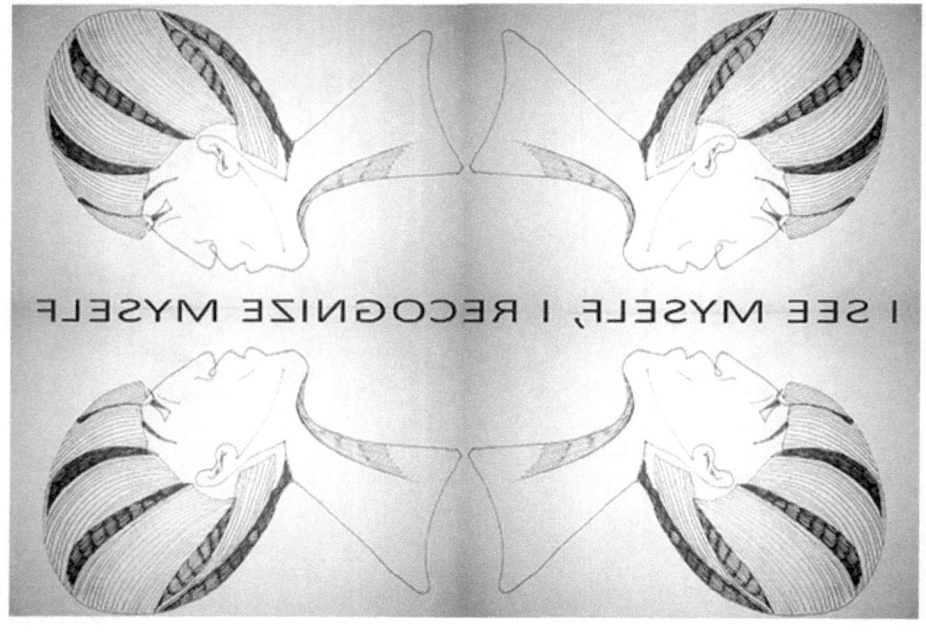

DUPLICITY IN THE MIRROR

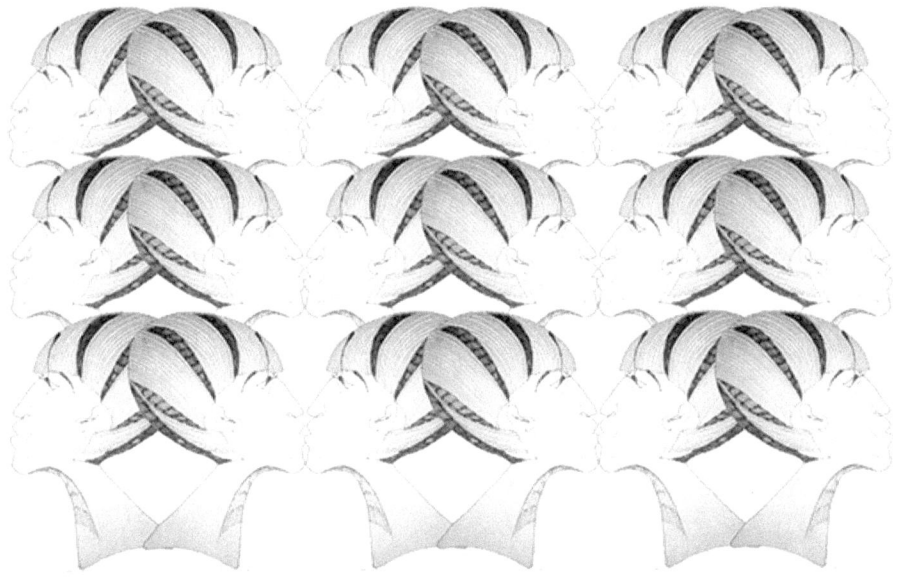

Chapter two

SUSPENDED EGO

The true voice: who speaks?

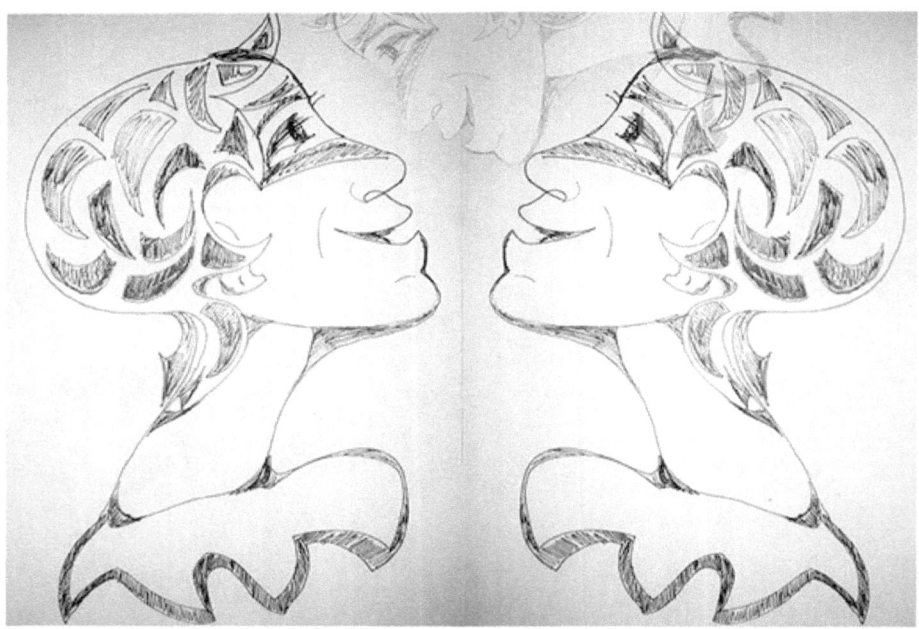

DUPLICITY IN THE MIRROR

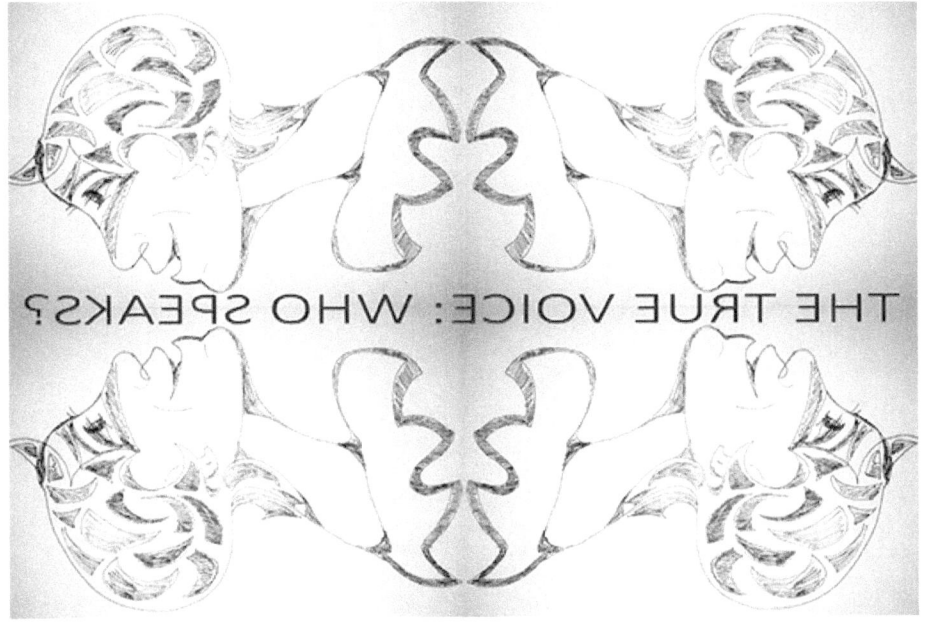

DUPLICITY IN THE MIRROR

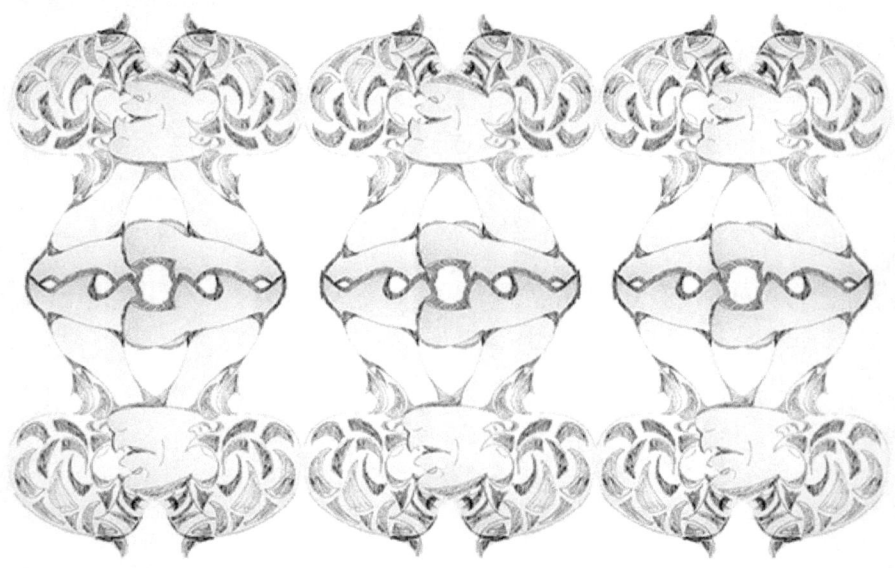

Chapter three

FRAGMENTS OF REALITY

The idden identity in the reflection of my double.

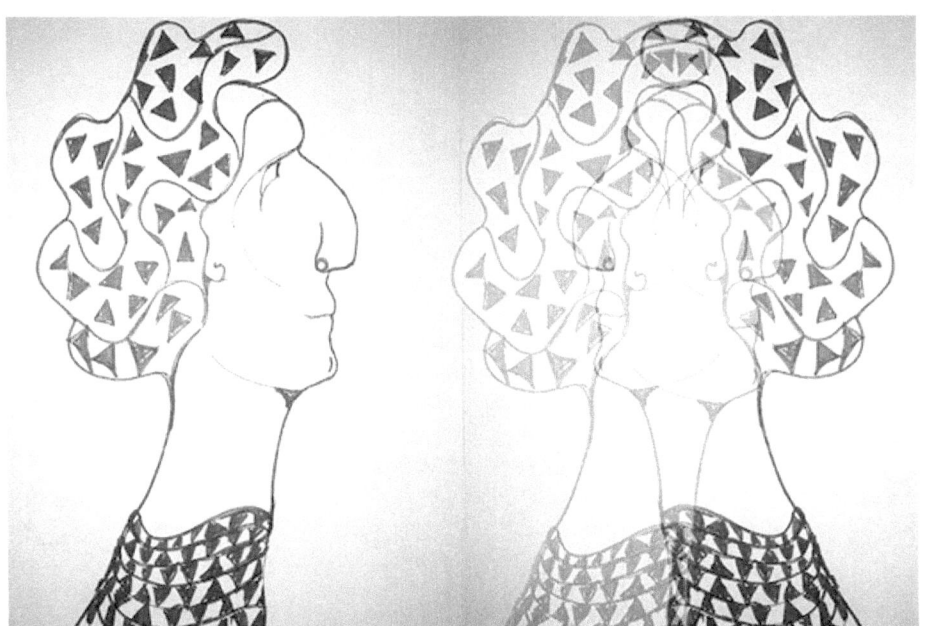

DUPLICITY IN THE MIRROR

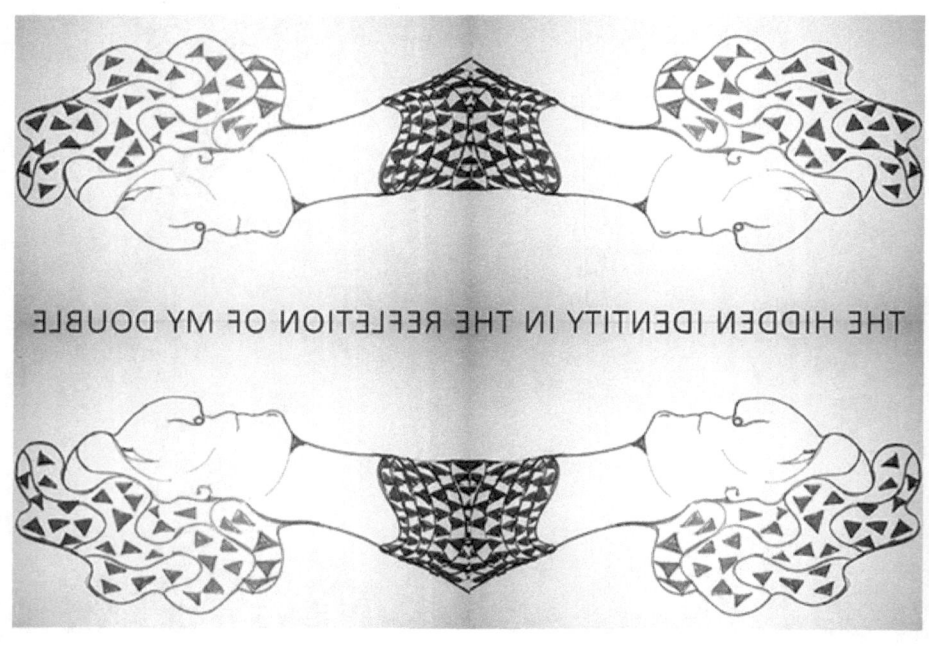

DUPLICITY IN THE MIRROR

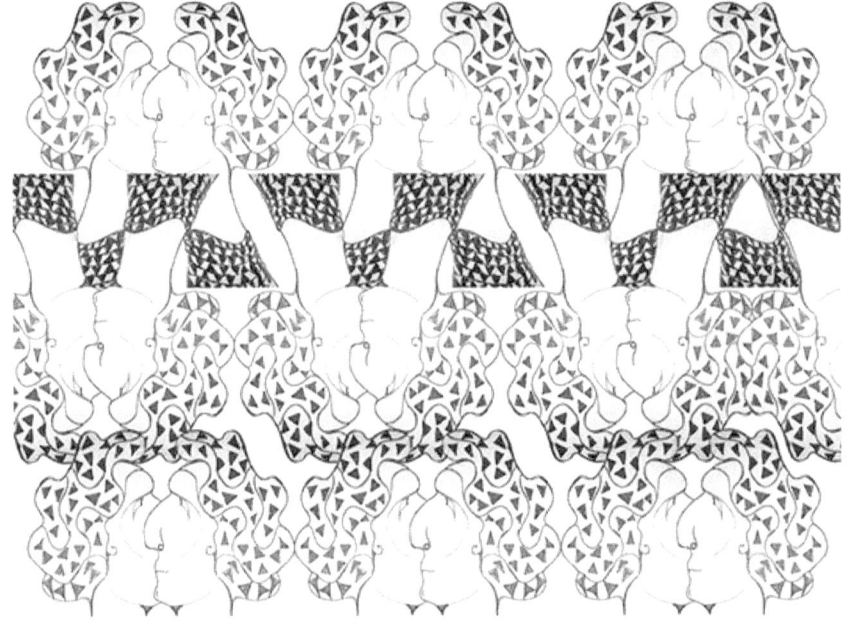

Chapter four

VANITAS VANITATUM

Vanitas vanitatum et omnia vanitas.

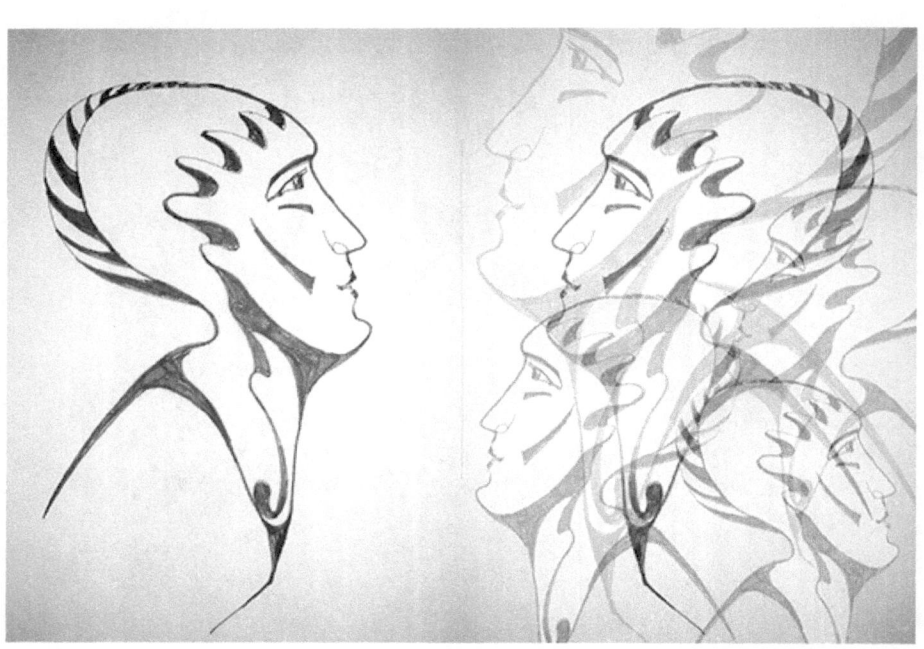

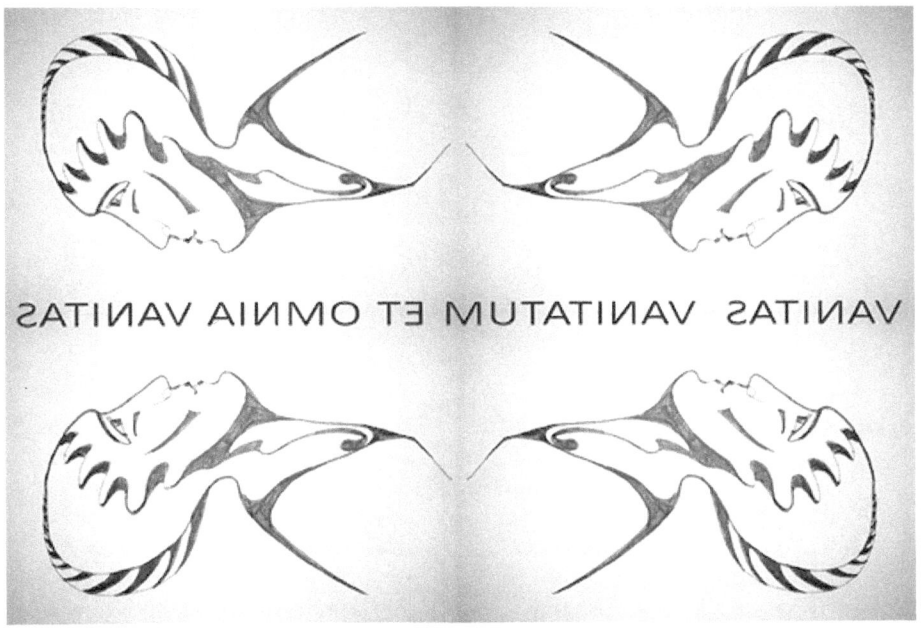

DUPLICITY IN THE MIRROR

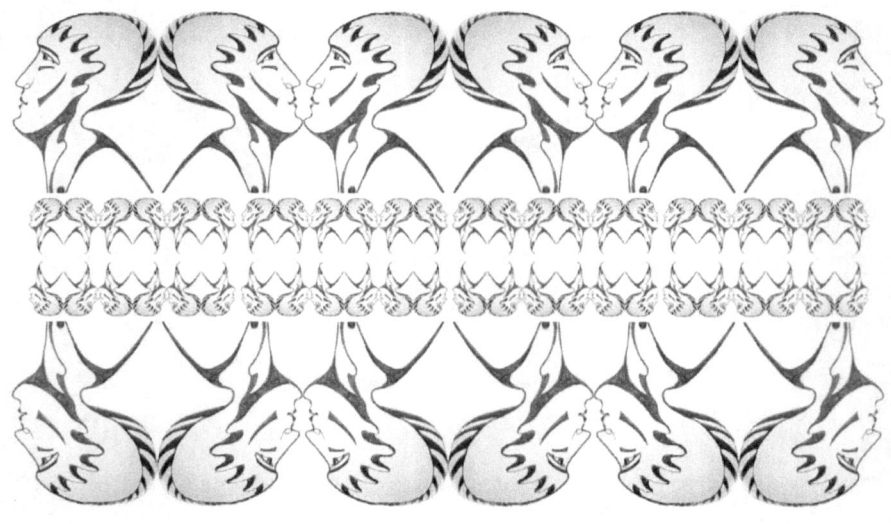

Chapter five

CADUCITY

Contemplation...Beauty...Unique quality...Futility...

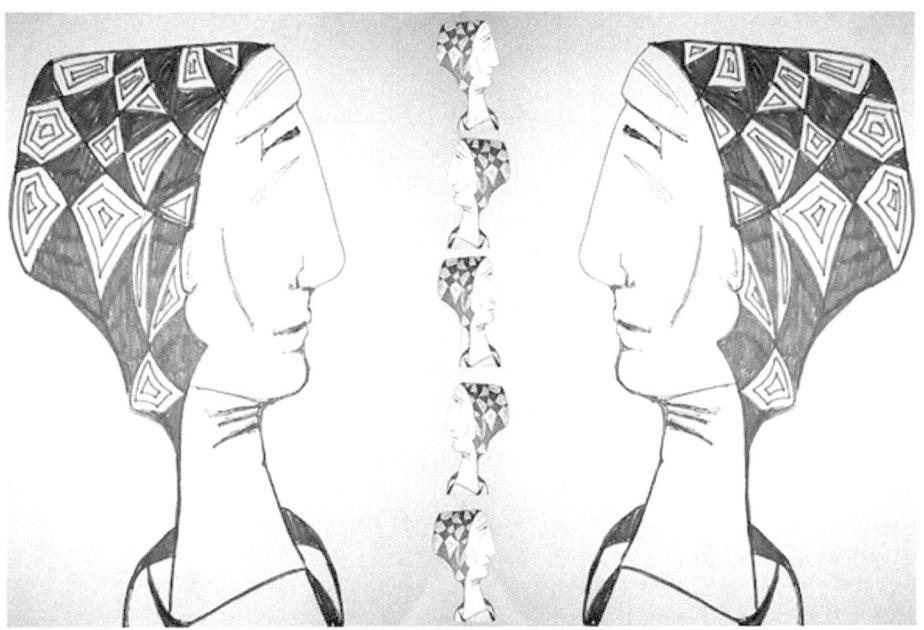

DUPLICITY IN THE MIRROR

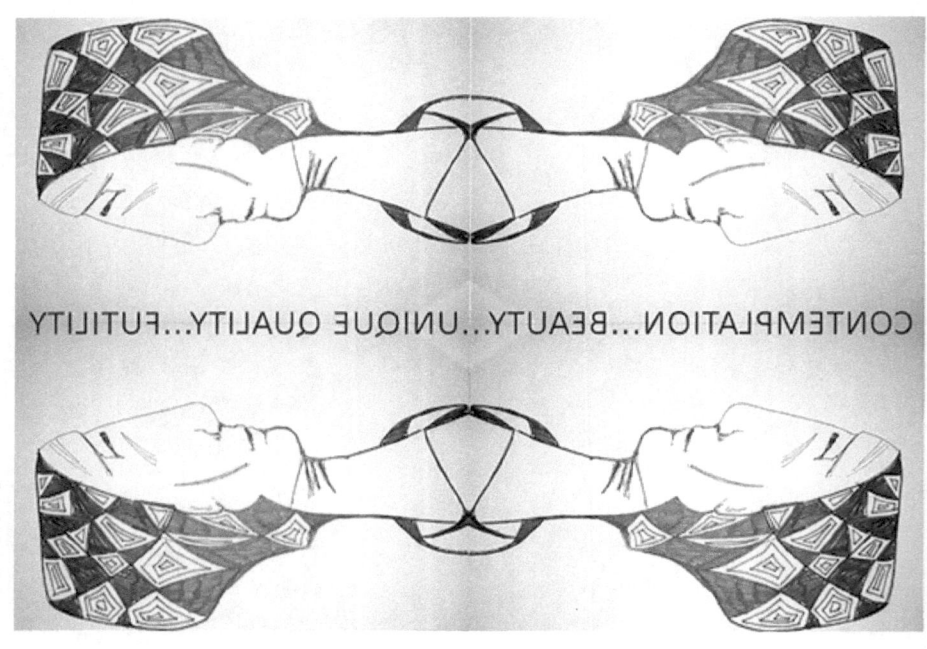

DUPLICITY IN THE MIRROR

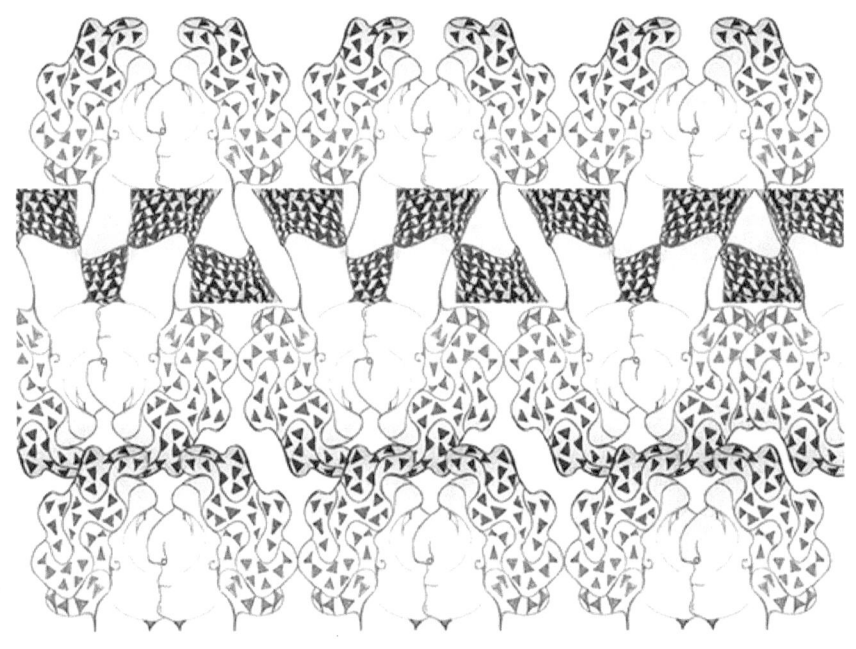

Chapter six

ABSTRACT CONCEPT

Logic and universal concept.

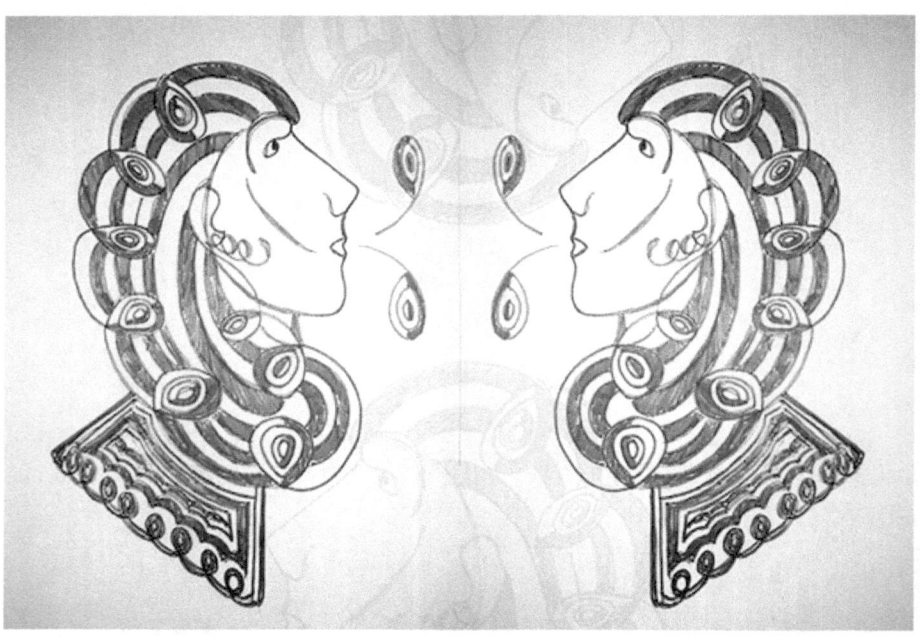

DUPLICITY IN THE MIRROR

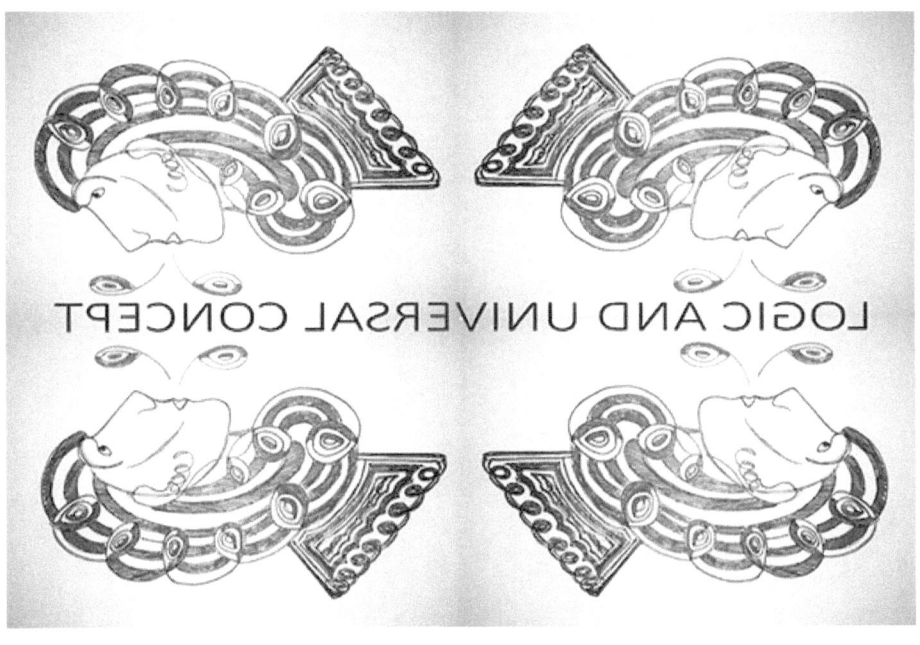

DUPLICITY IN THE MIRROR

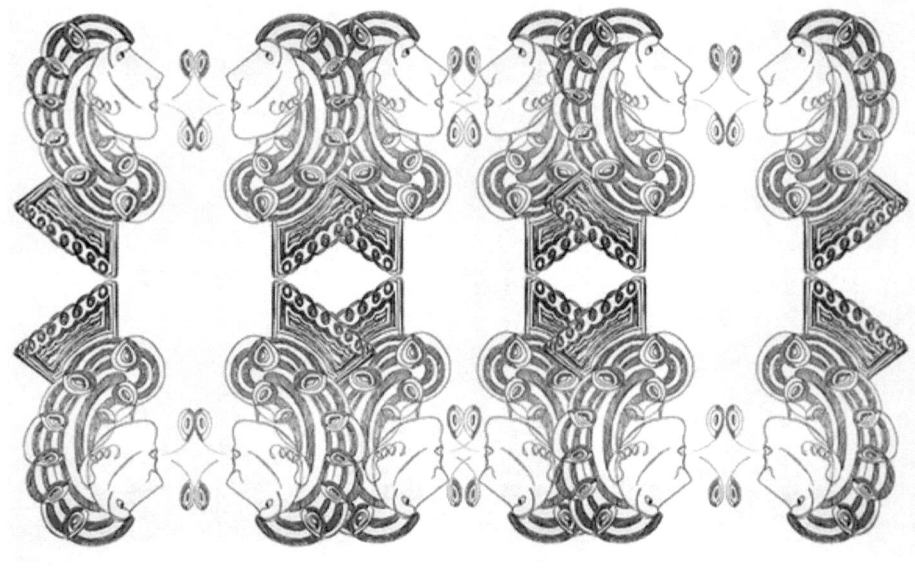

Chapter seven

REFLECTION

Identity reflected, absorbed, transmitted.

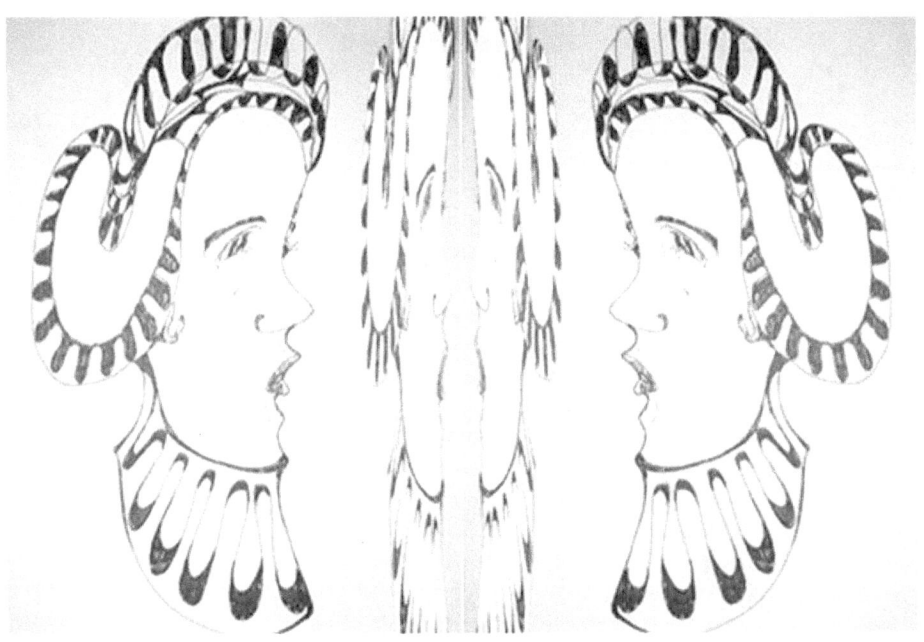

DUPLICITY IN THE MIRROR

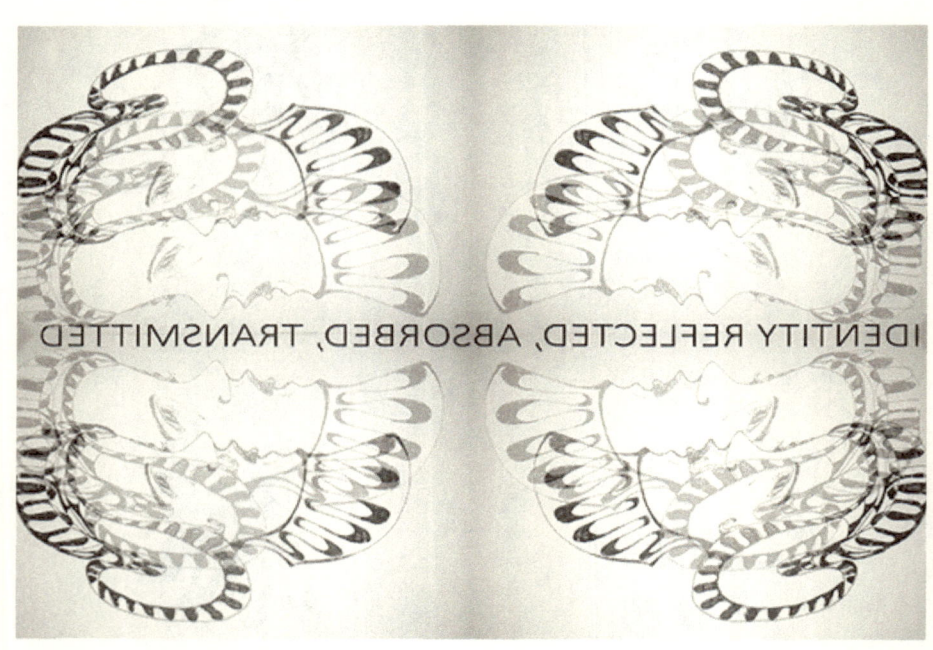

IDENTITY REFLECTED, ABSORBED, TRANSMITTED

DUPLICITY IN THE MIRROR

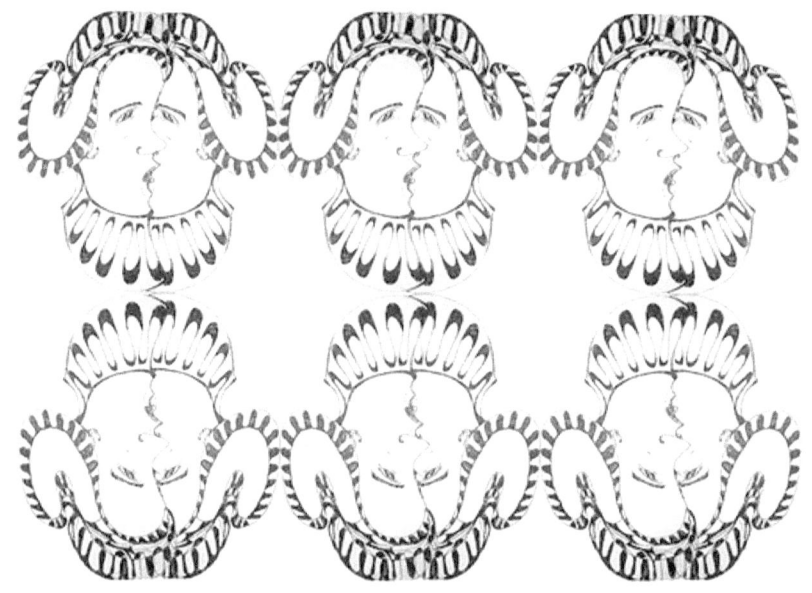

Chapter eight

SELF-REPRESENTATION

Modeling humanity: making man.

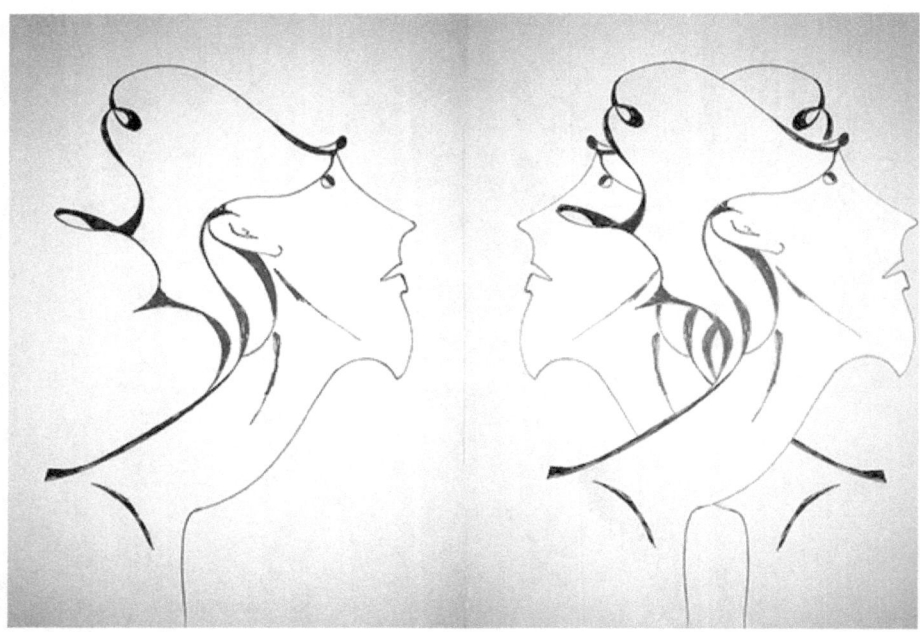

DUPLICITY IN THE MIRROR

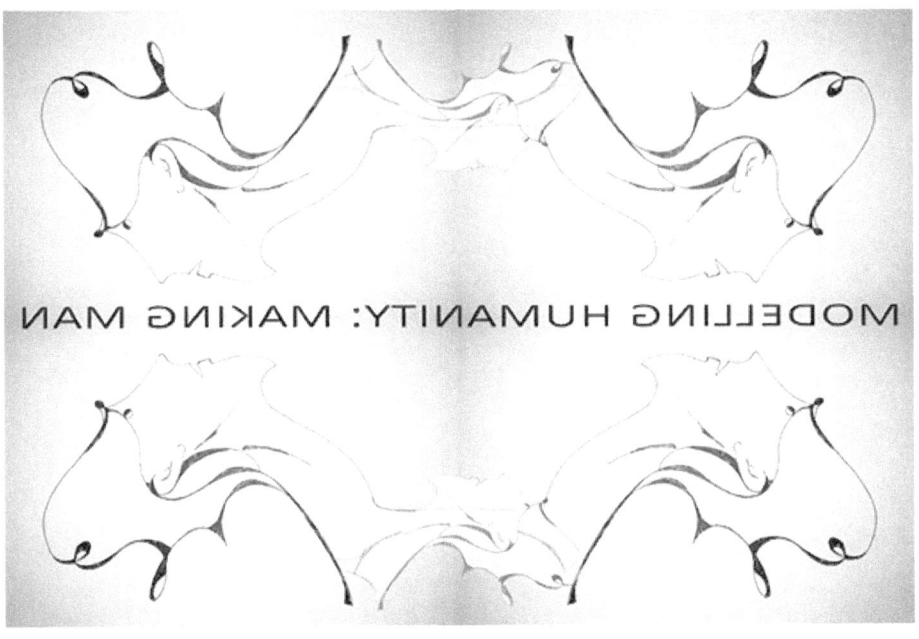

MODELLING HUMANITY: MAKING MAN

DUPLICITY IN THE MIRROR

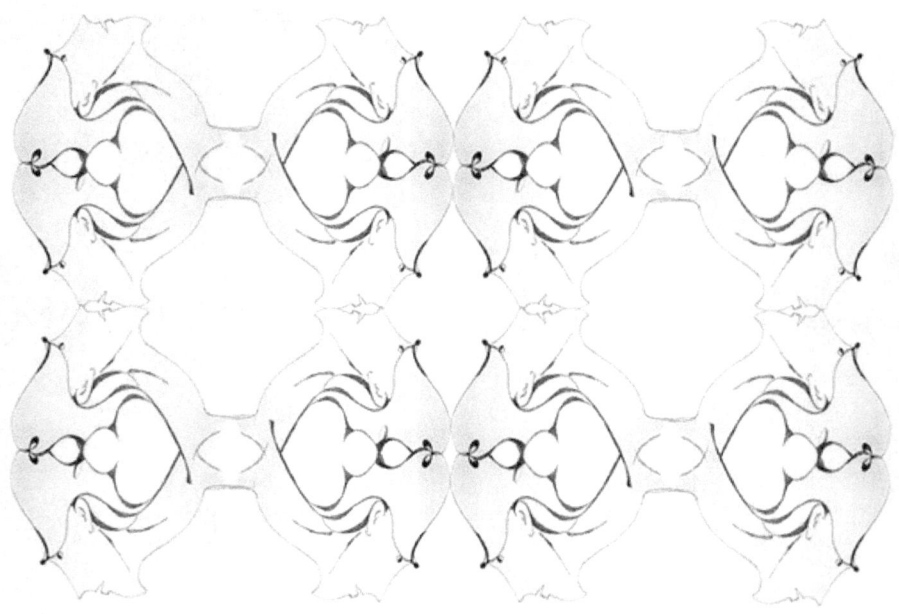

Chapter nine

PLURAL EGO

An identity that unfolds, and identity that is a story.

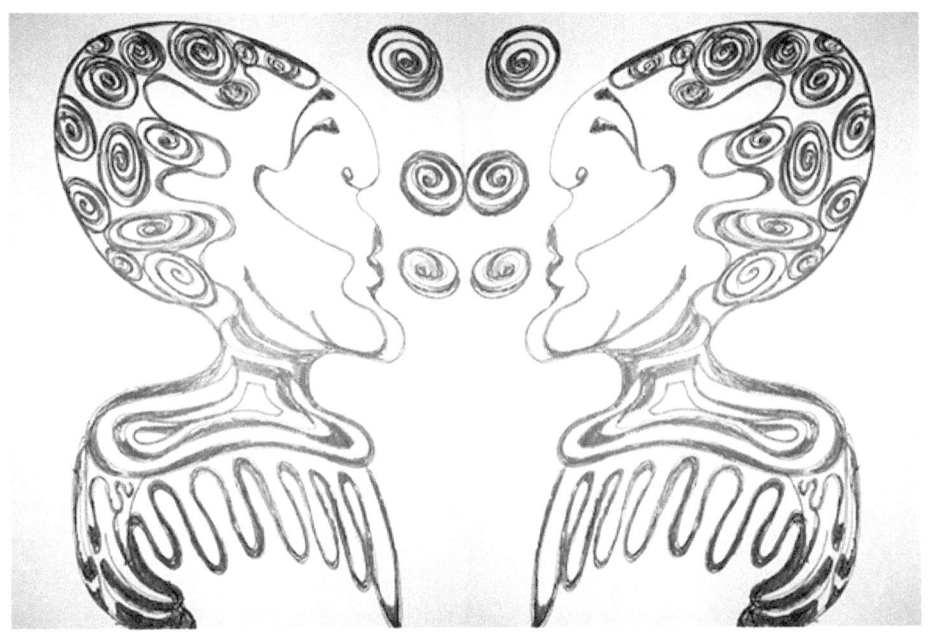

DUPLICITY IN THE MIRROR

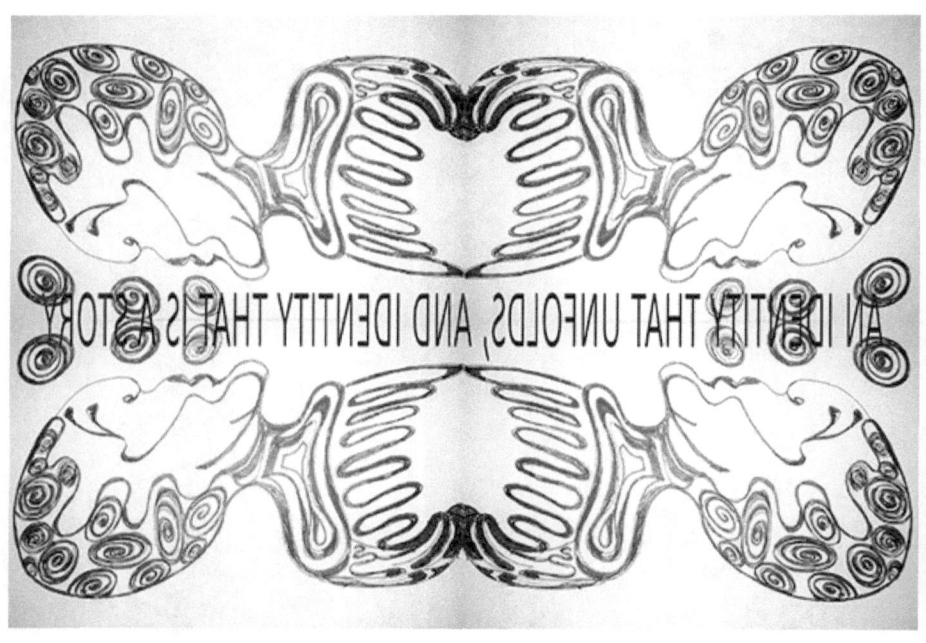

DUPLICITY IN THE MIRROR

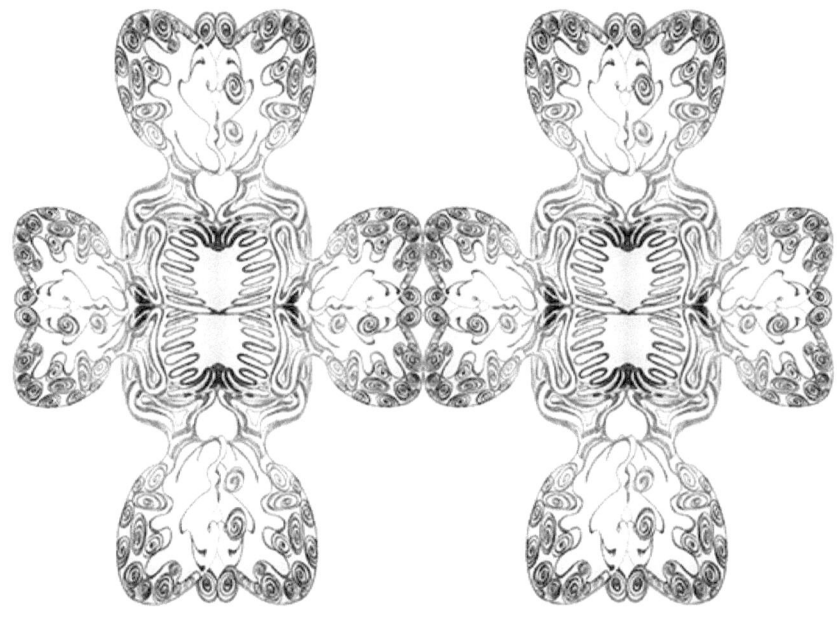

Chapter ten

THE TRUTH

An identity that unfolds, an identity that is a story.

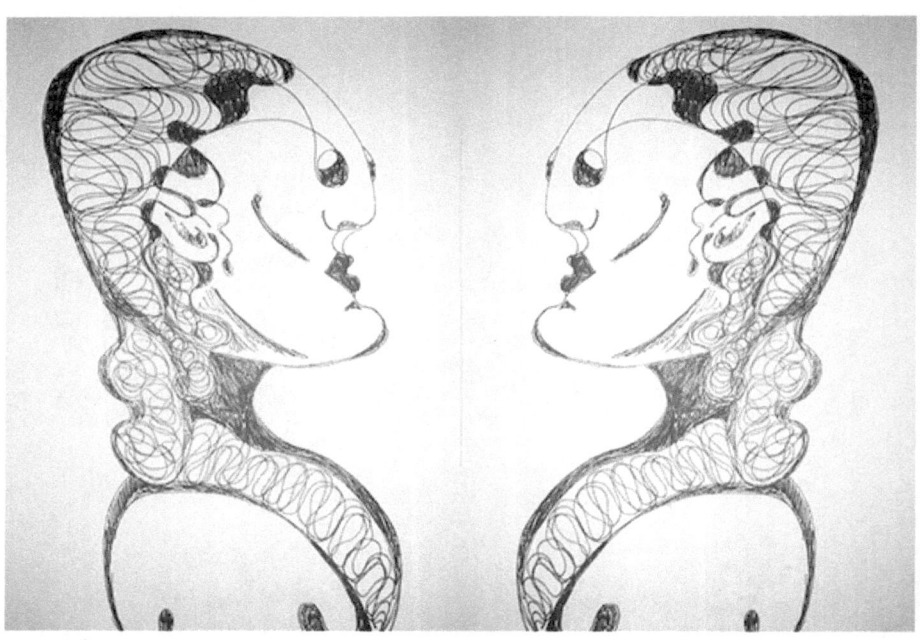

DUPLICITY IN THE MIRROR

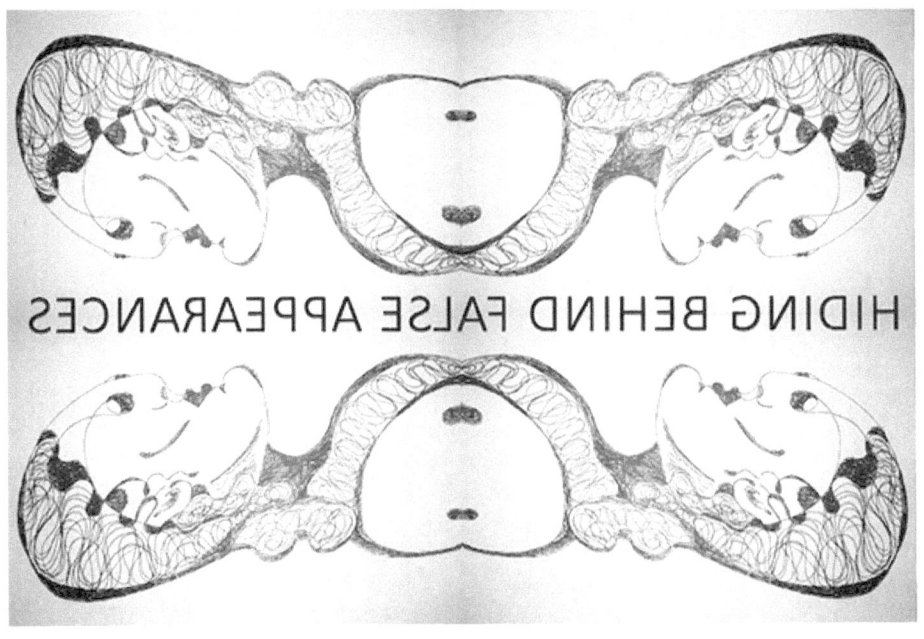

DUPLICITY IN THE MIRROR

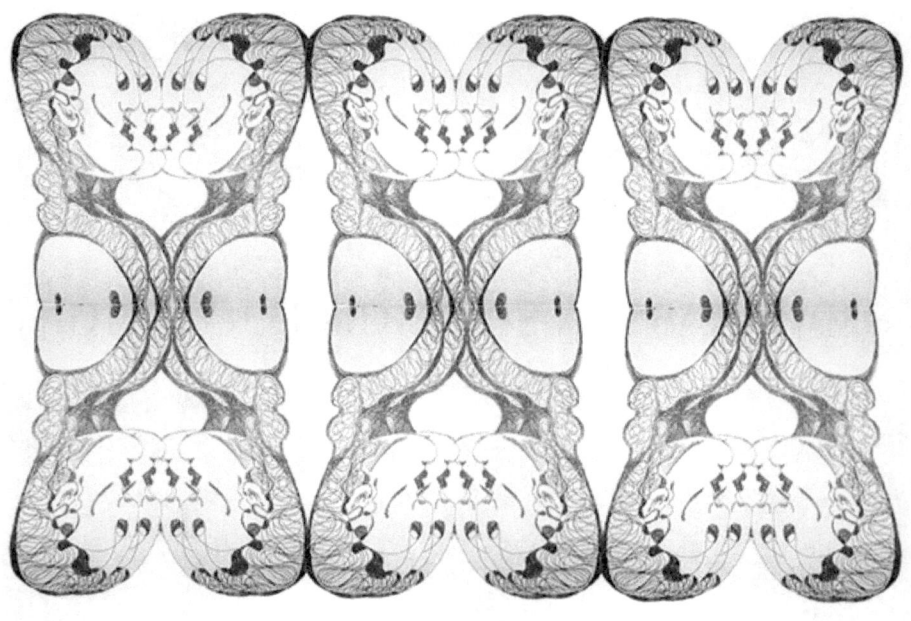

Chapter eleven

MULTIPLE IDENTITY

Looking for the next self.

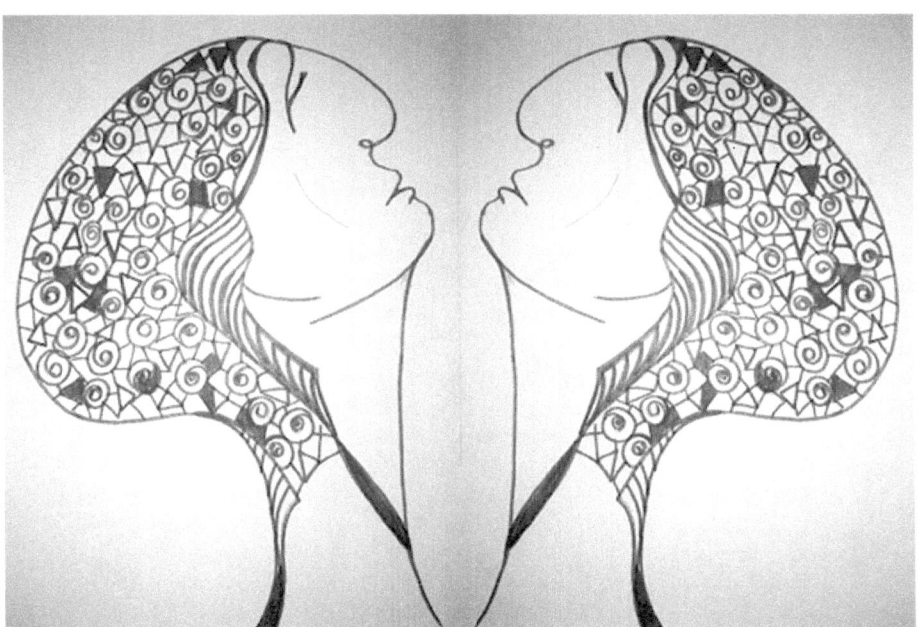

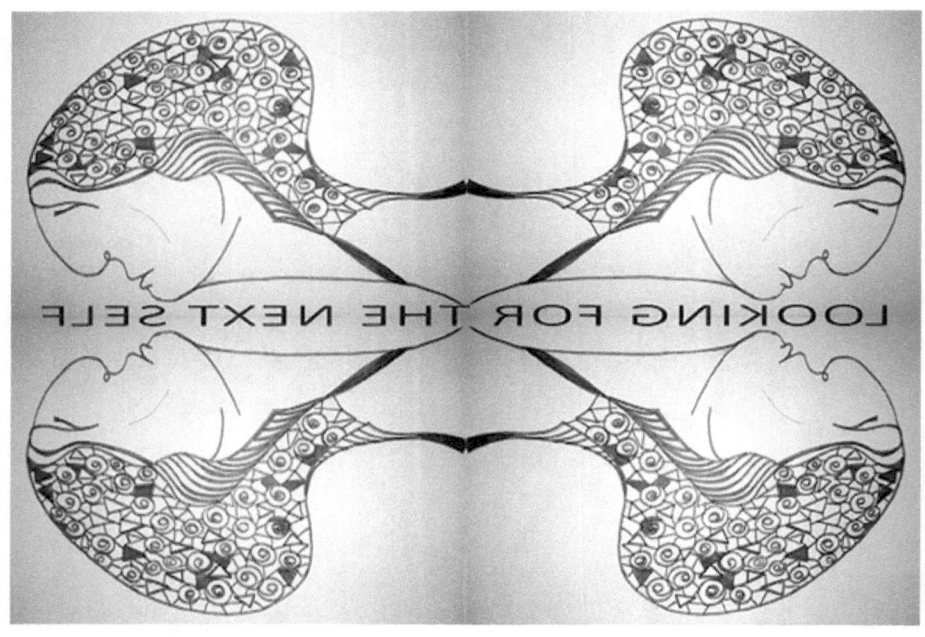

DUPLICITY IN THE MIRROR

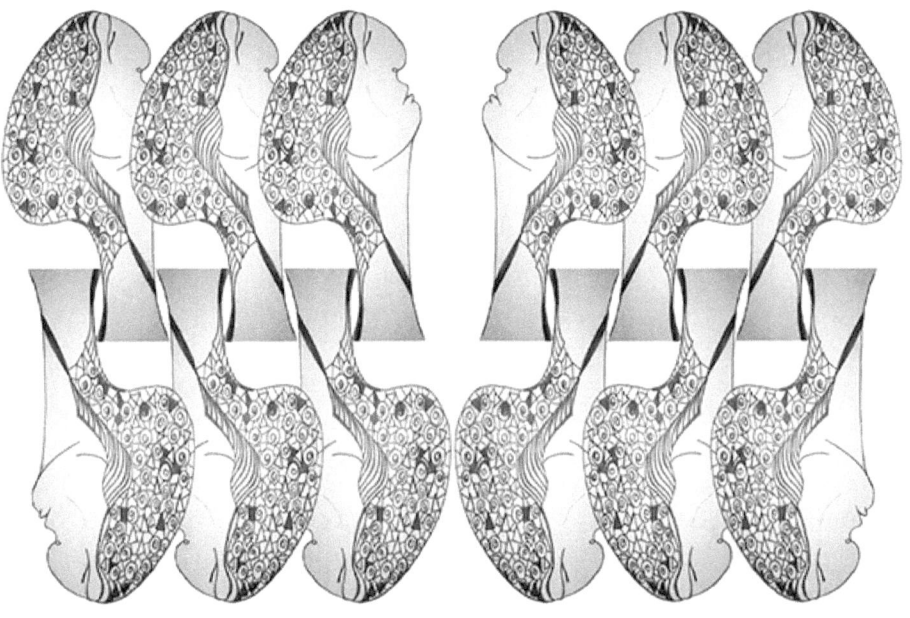

Chapter twelve

EGO HEADQUARTER

Intimate identity.

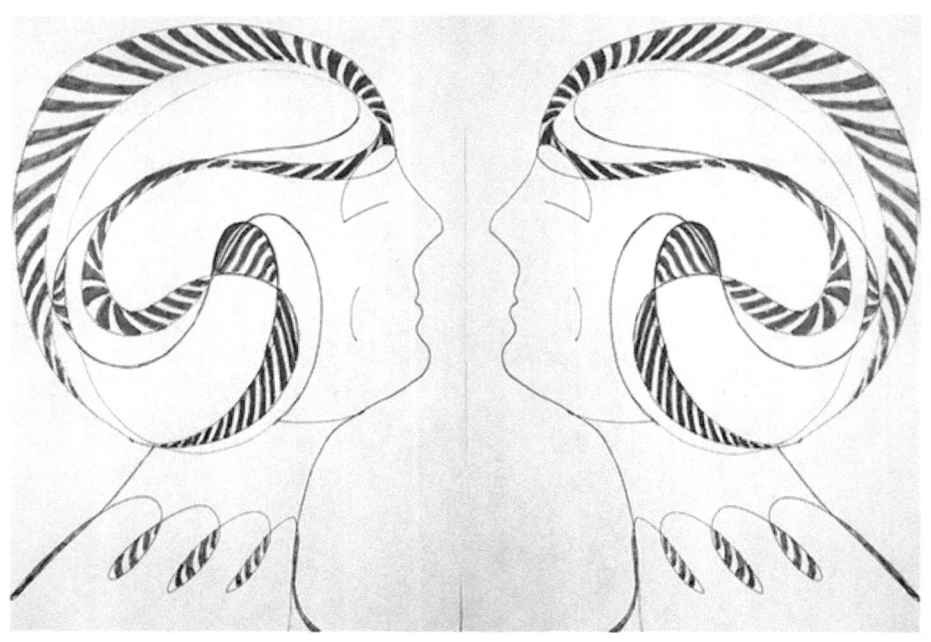

DUPLICITY IN THE MIRROR

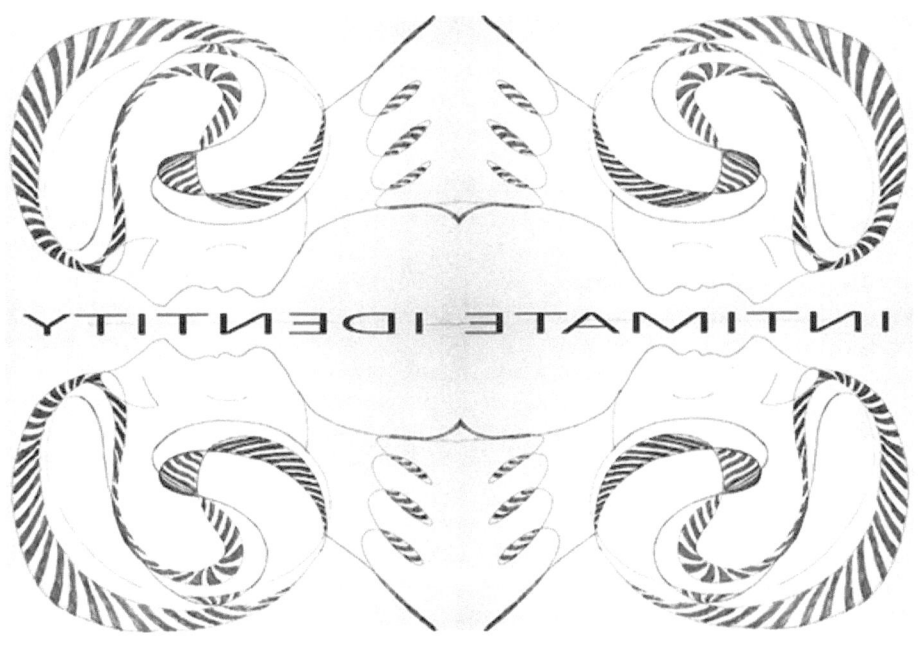

DUPLICITY IN THE MIRROR

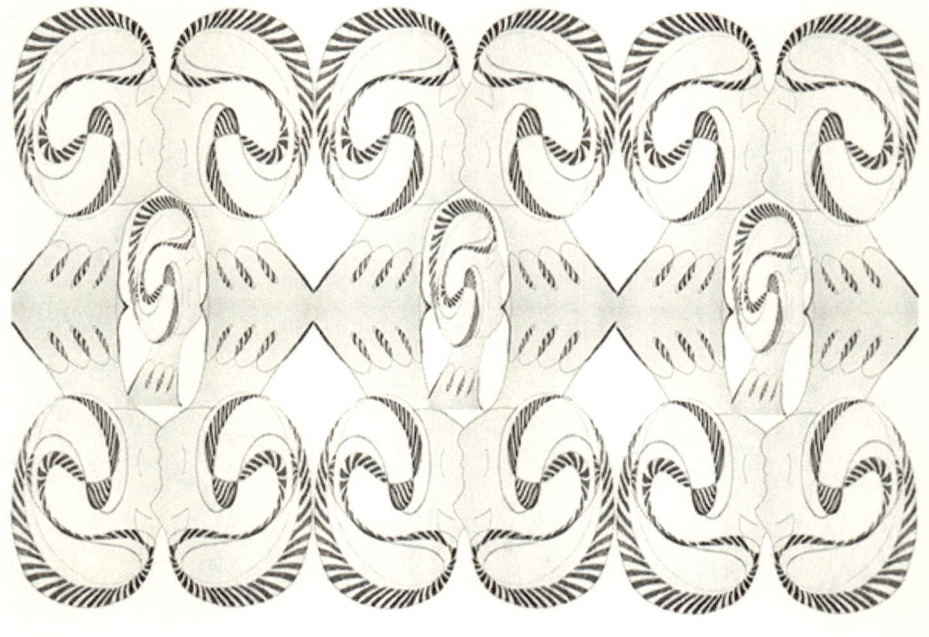

Chapter thirteen

THE IMAGINARY EGO

The other is me and I am the other.

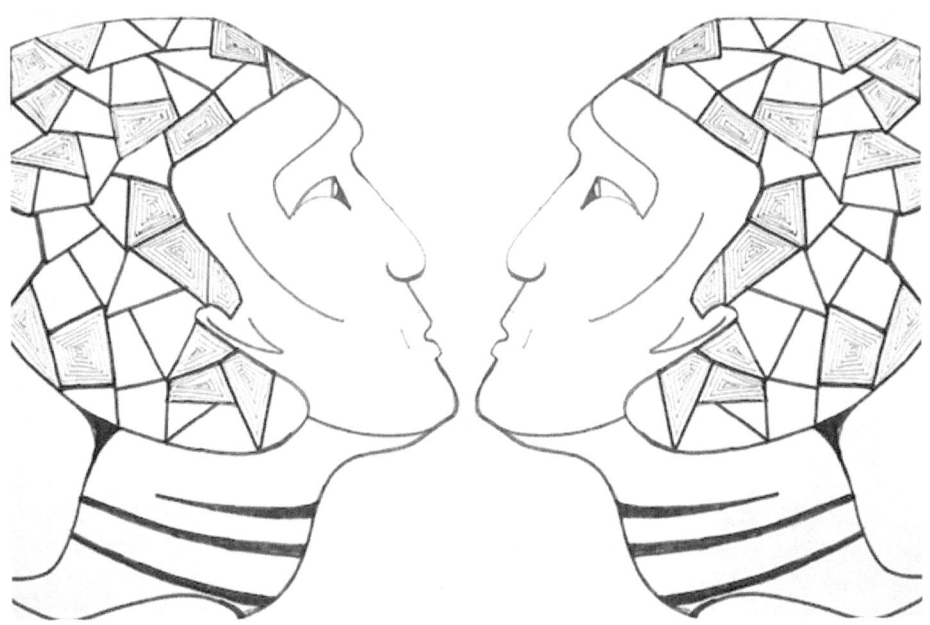

DUPLICITY IN THE MIRROR

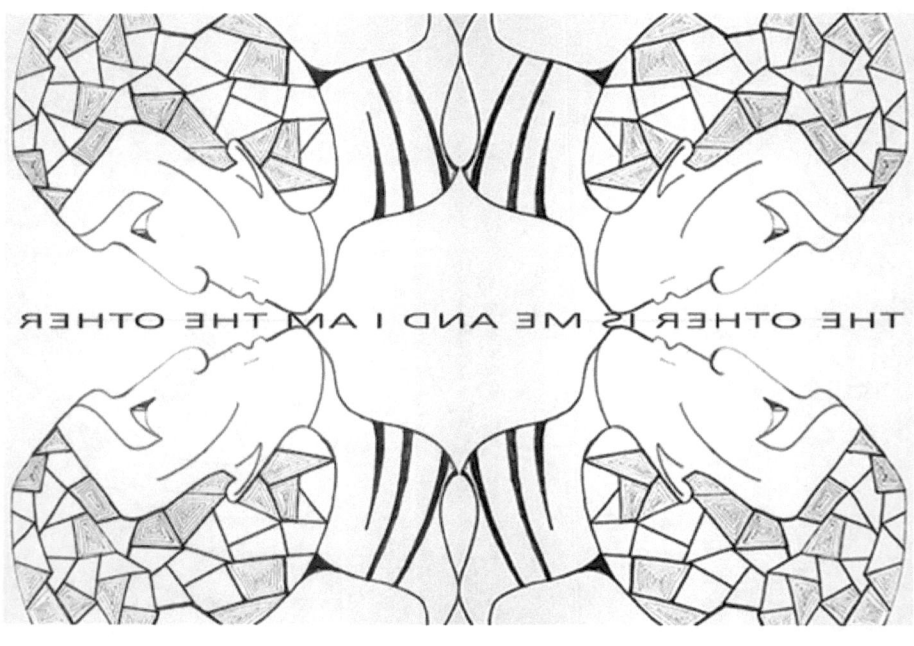

DUPLICITY IN THE MIRROR

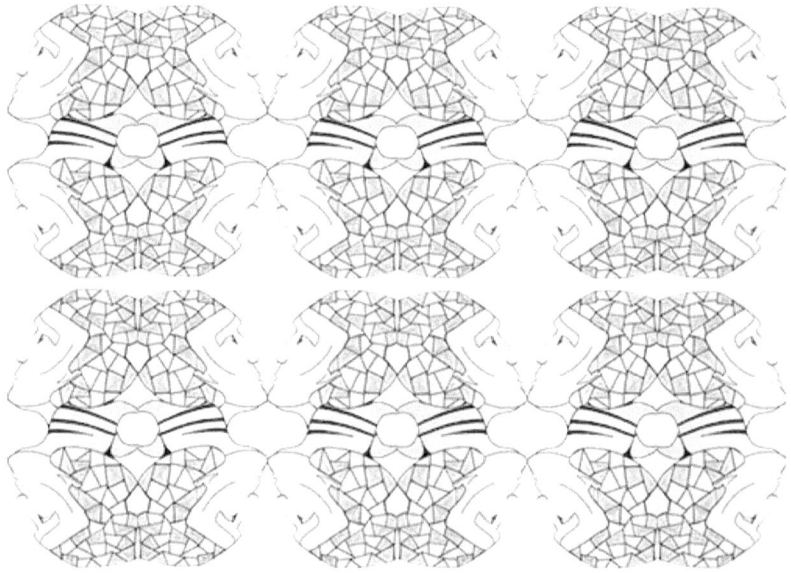

Chapter fourteen

THE OBJECTIVE IMAGE

The illusion of the ego.

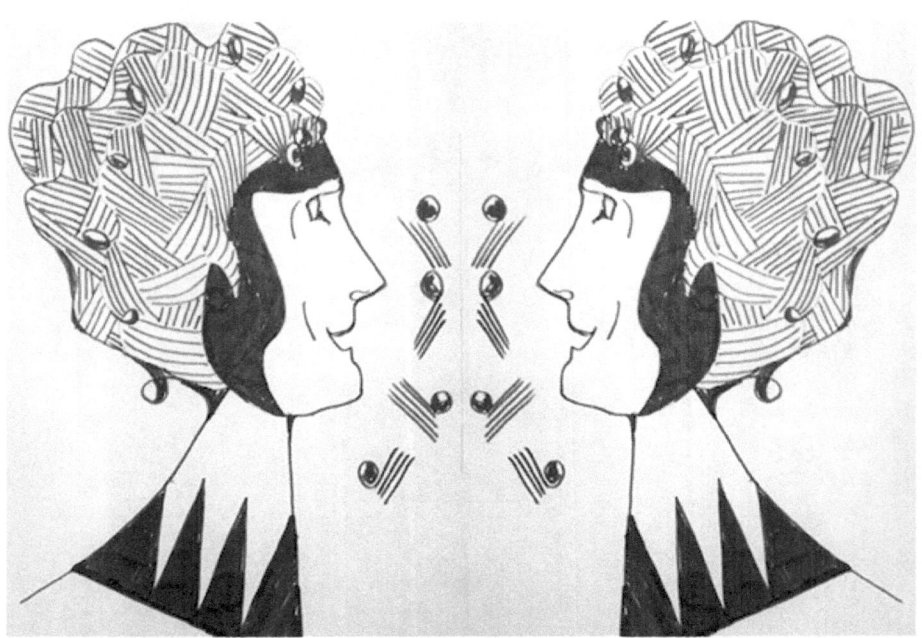

DUPLICITY IN THE MIRROR

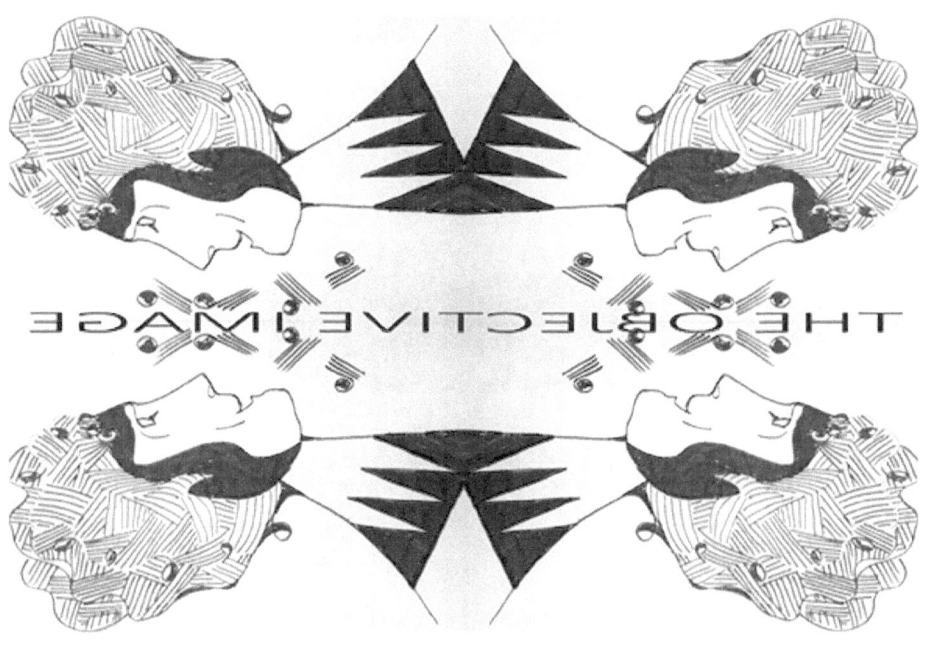

DUPLICITY IN THE MIRROR

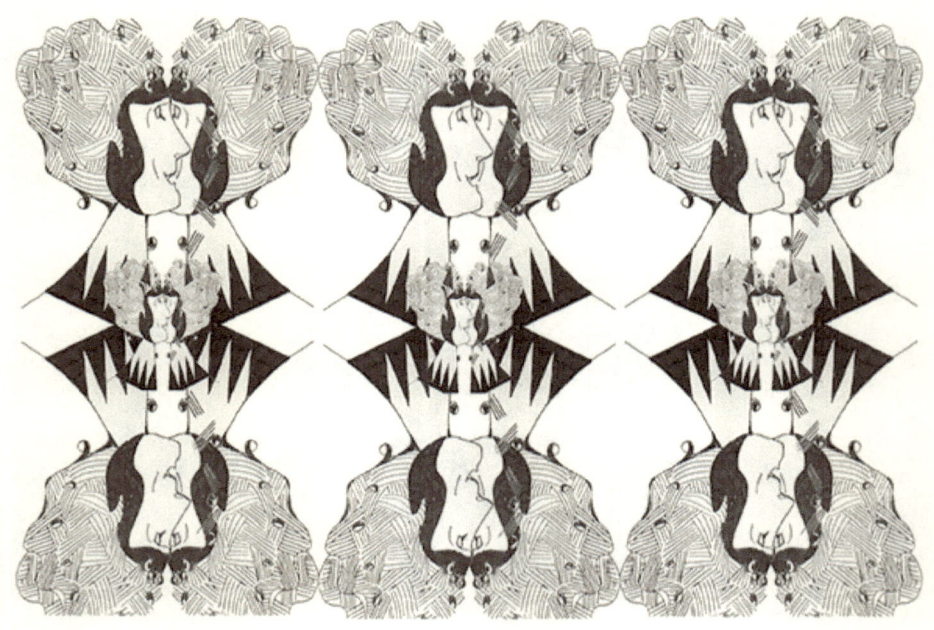

Chapter fifteen

IN DUAL MODE

The spirit is the perfect synthesis of our duality.

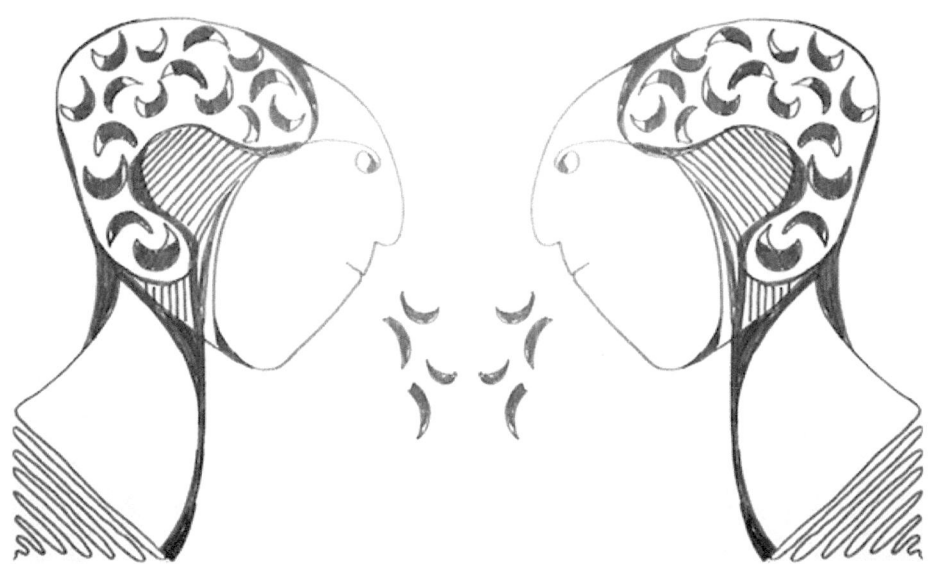

DUPLICITY IN THE MIRROR

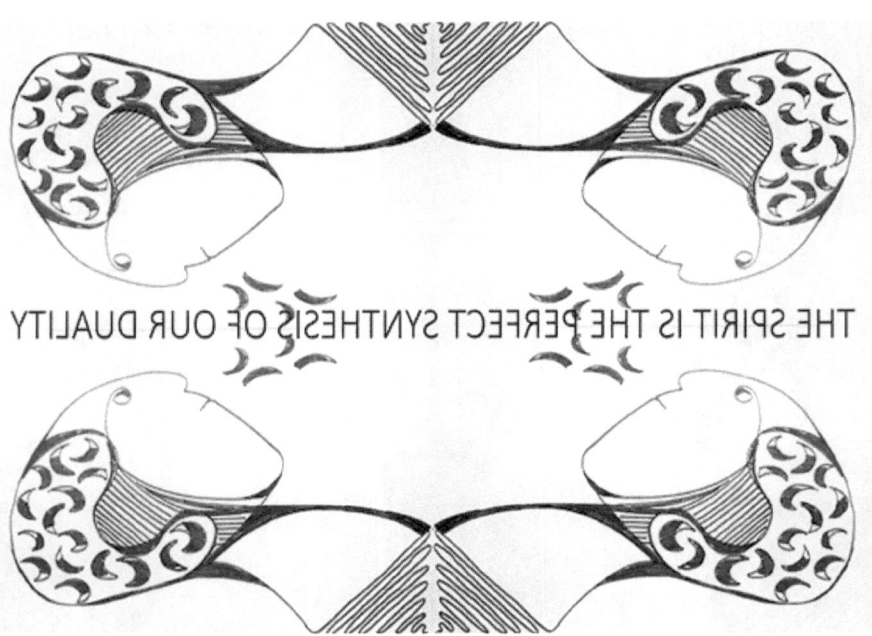

DUPLICITY IN THE MIRROR

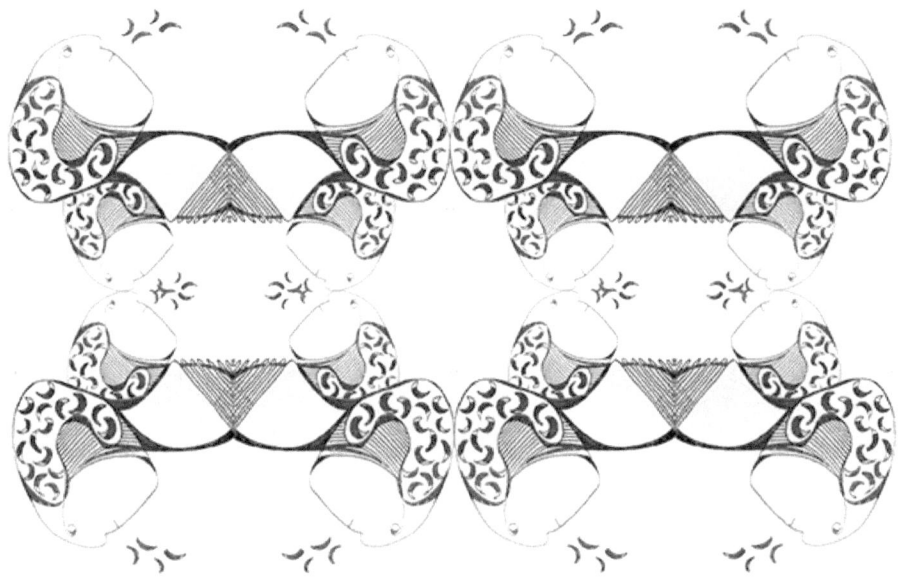

Chapter sixteen

THE OPPOSITES

A look on our ego.

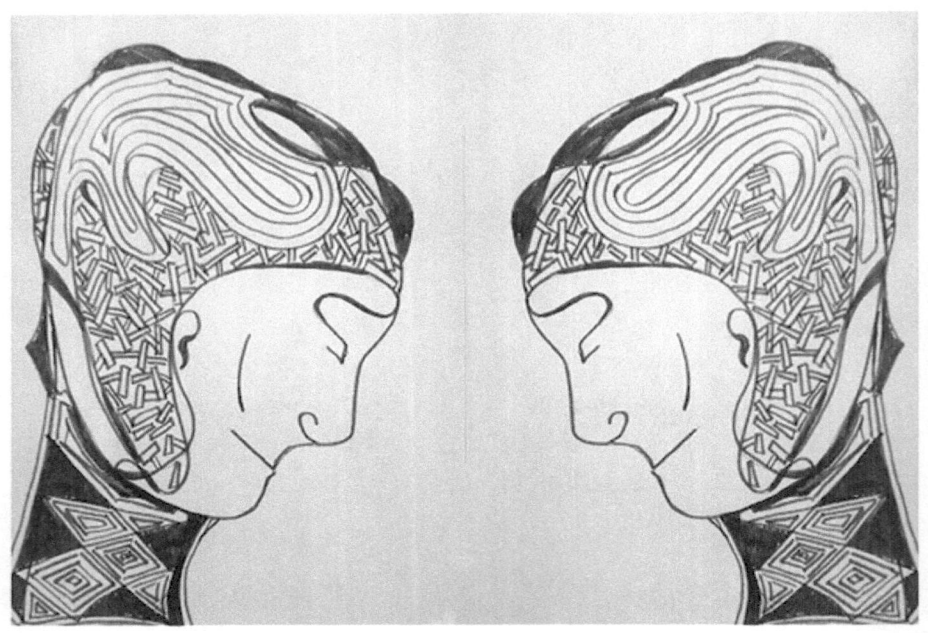

DUPLICITY IN THE MIRROR

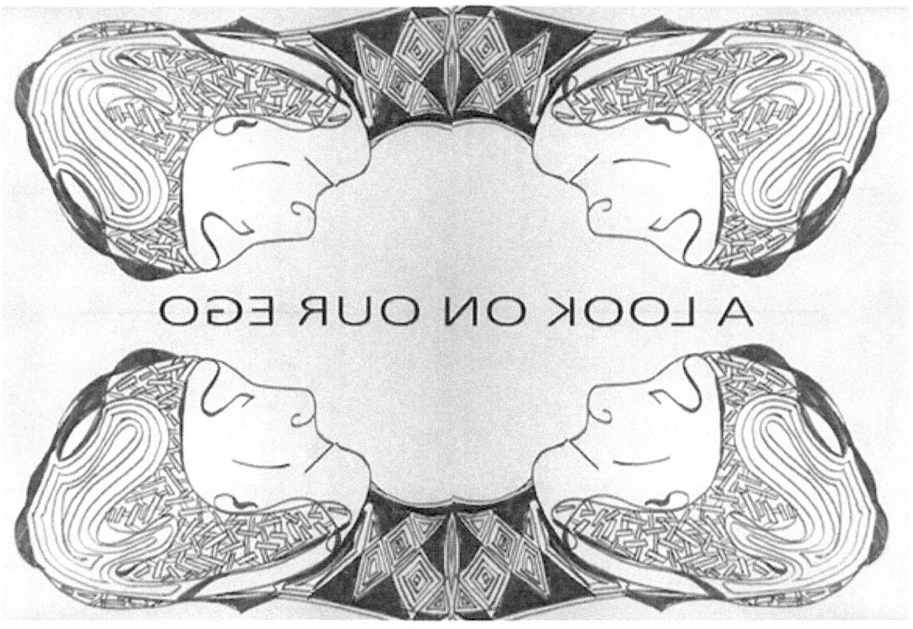

DUPLICITY IN THE MIRROR

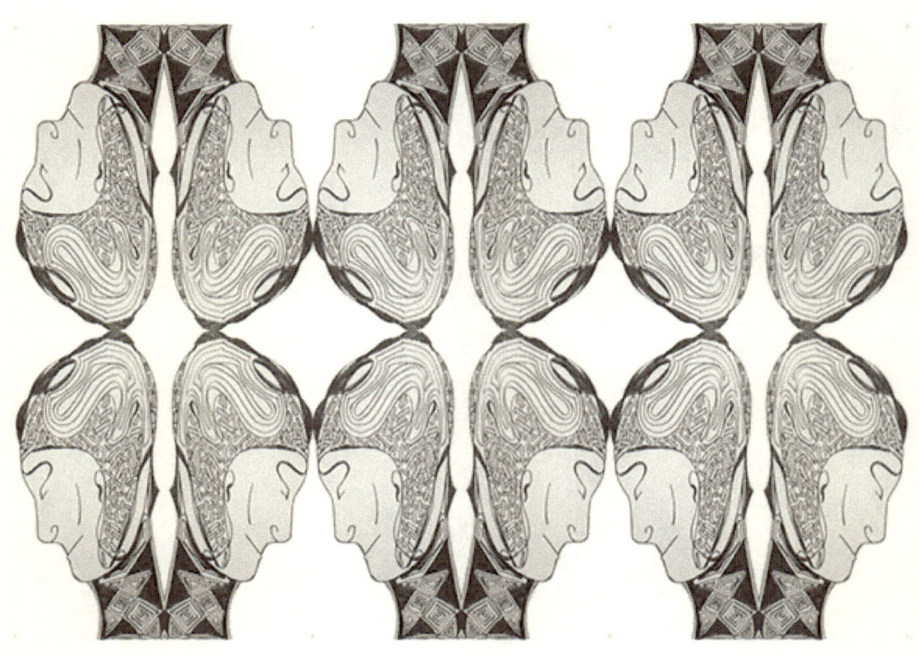

Chapter seventeen

CONTEMPLATION

Contemplate inner images.

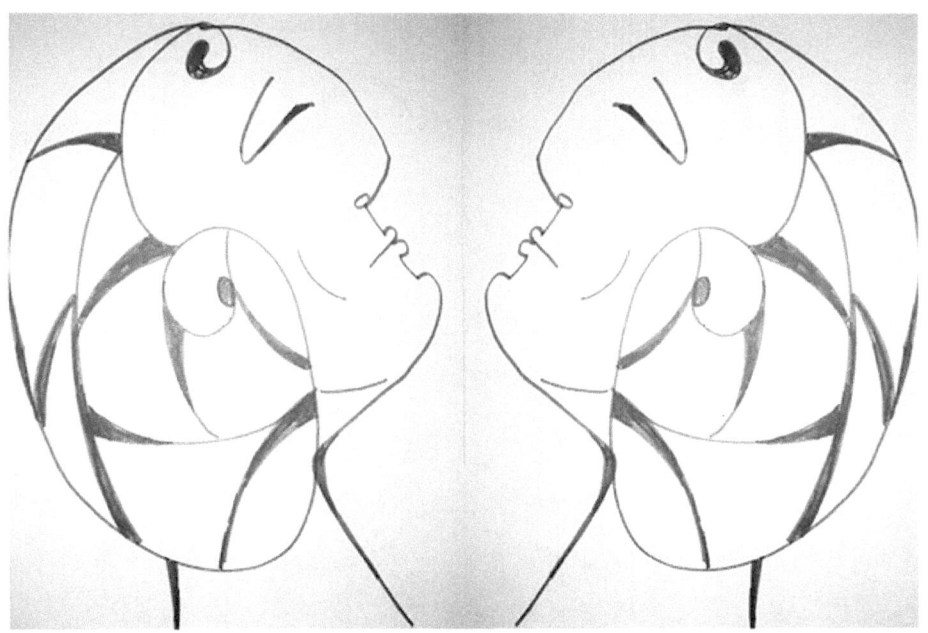

DUPLICITY IN THE MIRROR

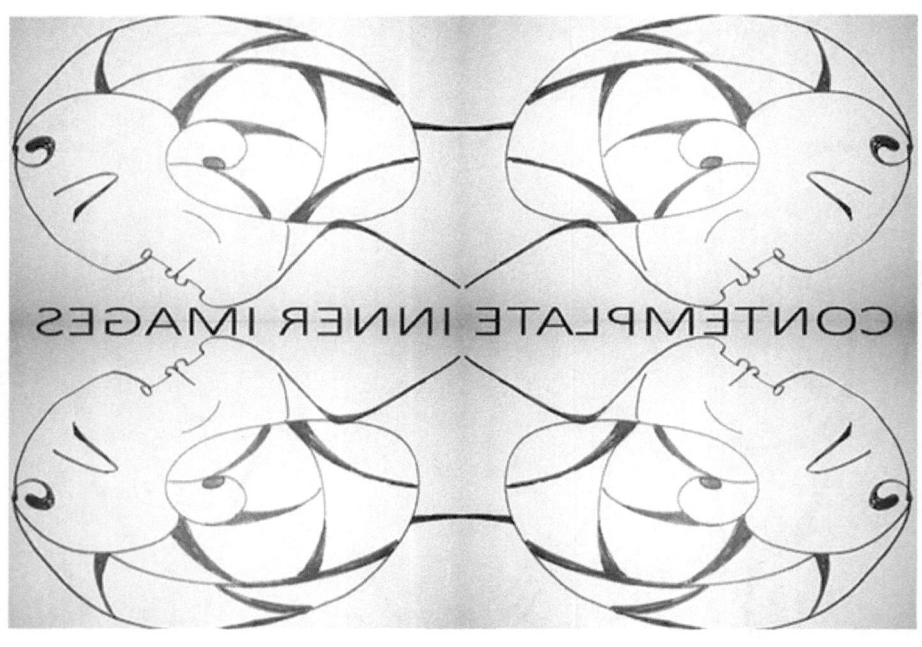

DUPLICITY IN THE MIRROR

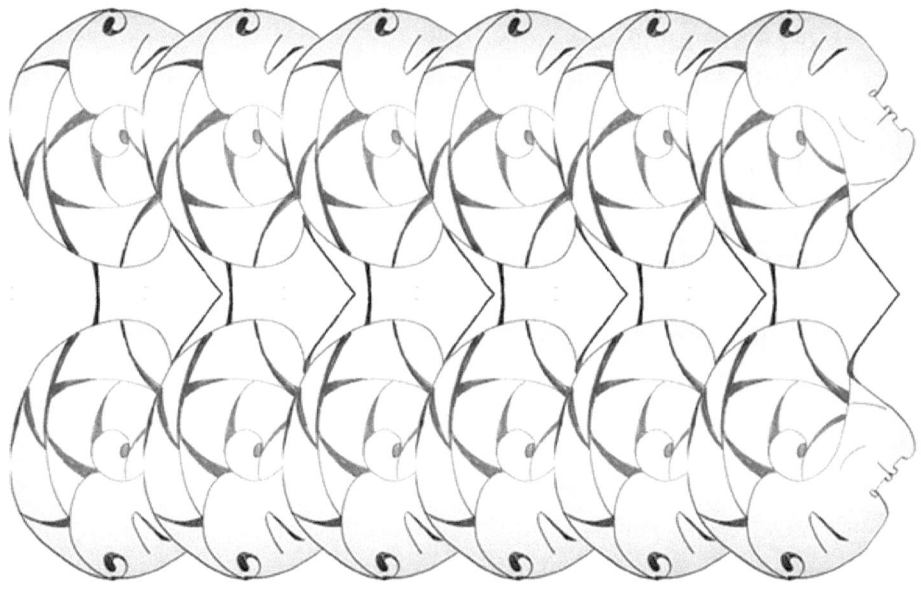

INDICE

	INTRODUCTION	pag. 2
1	A QUESTION OF PERCEPTION	pag. 5
2	SUSPENDED EGO	pag. 8
3	FRAGMENTS OF REALITY	pag. 11
4	VANITAS VANITATUM	pag. 14
5	CADUCITY	pag. 17
6	ABSTRACT CONCEPT	pag. 20
7	REFLECTION	pag. 23
8	SELF REPRESENTATION	pag. 26
9	THE PLURAL EGO	pag. 29
10	THE TRUTH	pag. 32
11	MULTIPLE IDENTITY	pag. 35
12	THE HEADQUARTER OF EGO	pag. 38
13	THE IMAGINARY EGO	pag. 41
14	OBJECTIVE IMAGE	pag. 44
15	DUAL MODE	pag. 47
16	THE OPPOSITES	pag. 50
17	CONTEMPLAZIONE	pag. 53

DUPLICITY IN THE MIRROR

Finished printing in Novembre 2018
CINZIA BIANUCCI

DUPLICITY IN THE MIRROR

CINZIA BIANUCCI

Artist and Designer. Born in Magenta (Milan) in 1963.
Supported by her passion for art, she has always practiced drawing, painting and design all the time. The constant attendance with artists and creatives has strengthened his experience.

Active in various capacities in the art world since 1995, she has organized exhibitions and events in collaboration with public and private institutions. Numerous collaborations with excellent people in the world of culture, art and direction. From his decades of experience as a creative
designer, projects and accessories are born with the pursuit of cutting-edge style: a rich selection of ideas with a communicative, figurative impact and original results.

With a sensitivity that is attentive to understanding the subtle signals of change that transforms into artistic expression, it is always immersed in continuous research.

DUPLICITY IN THE MIRROR

www.ingramcontent.com/pod-product-compliance
Lightning Source LLC
Chambersburg PA
CBHW030525220526
45463CB00007B/2726